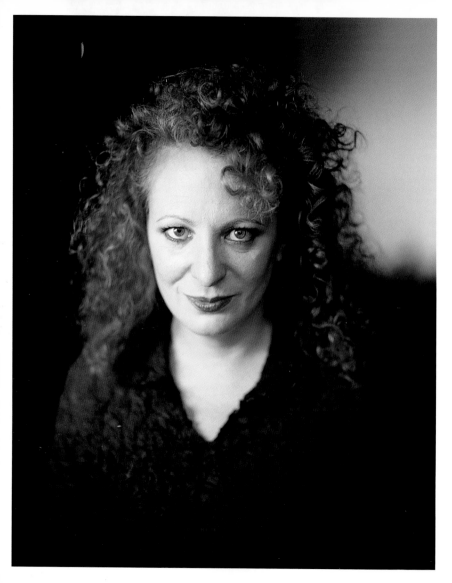

2.3

It is difficult for me to talk about Nan Goldin's work without first talking about her; my lack of distance from all I have to say would hinder me as I wrote. And I might even feel a little ridiculous. I have known her for many years and I have travelled to many parts of the world with her, in Europe and beyond, on professional assignments and purely for pleasure. She has photographed me more often than I can remember, and her 'family', made up of her many friends scattered all over the world, is also mine.

Fortunately, with Nan Goldin's photography, a certain kind of critical caution is entirely unnecessary. Nan and her photographs form a single whole, and those who look at them, in that moment when they really understand them, become irresistibly drawn into their world; they are interrogators, but at the same time, are being interrogated. The spectator must to some degree become an active participant in the taking of the picture, reconstructing what went before and the circumstances in which it was made. In other words, he or she must, for a brief moment, agree to become part of Nan Goldin's extended family.

This rite of mutual recognition — familiar in tribes, clans, or groups sharing a common mental or spiritual outlook — is not elitist, or defined by class, taste or nationality. Even at its crudest or most marginal, her photography succeeds in using common archetypes, collective memories, stories with which most of us can identify. Frequently (but superficially) Goldin's work is seen as a mirror held up to her generation, or as a disenchanted record of recent moments in our collective experience. This is not strictly true, and a tendency merely to chronicle reality, dressing it up in the garb of a new kind of realism, is characteristic of those aspects of Goldin that have filtered down to her thousands of followers and imitators, those who have been quick to turn her into a model of

style. But it is certainly the case that few other photographers have had such a powerful influence on a particular way of making photography – namely, that of approaching the subject with a new sensitivity, gradually making it part of a 'work in progress' that is no longer simply photography. From this point of view, Nan Goldin is a case apart.

Goldin is, first and foremost, a Romantic artist, anti-ideological and by no means heavy-handed, more an ethical being than a moralist. Her work goes beyond the traditional conventions of photography (ie. as a representation of reality) and raises issues such as the relationship between truth and simulation, individual and collective history, prose and poetry. She has succeeded in creating narratives that cut right across 'official' history and its confining categorizations. Consequently, asking questions about her work is like entering an infinity of mirrors. It means not only asking questions about her, but, to a certain extent, about ourselves. More precisely, what aspects of ourselves do we recognize in her?

It all began in the early 1960s in a middle-class home in a sleepy neighbourhood of Washington DC. The Goldin family – four children, their father, a liberal and progressive mother who rallied for civil rights with her children – was a typical, intellectual Jewish family of suburban America, ill at ease in such a conservative milieu.

An old Polaroid snapshot shows them all together, in what might be a restaurant, celebrating a holiday. The year is 1964. Barbara Holly and Stephen are in the foreground, sitting beside their parents; behind them, not yet in their teens, are Nancy and Jonathan. Nancy, wearing a white Alice band, is the only one not

looking at the camera. She is ten years old, and dreams of becoming a pyscho-analyst. Her elder sister Barbara Holly, her soul-mate and role model, is a talented and dedicated pianist. Another year of pleasant suburban dullness follows – a year lived, as is every young girl's right, in the golden glow of the 'American dream' – and then darkness falls.

On 12 April, 1965, Barbara, aged eighteen, decided to end her own life violently, and it was as if life had come to an end for the whole family. Her parents refused to deal with the guilt and loss, and denial became a way of survival. The most important thing was that the neighbours shouldn't know anything. They also tried to keep Nancy in the dark, telling her Barbara had had a terrible accident, but sensitive and traumatized as she was, she immediately realized what had happened. This is perhaps the origin of her voracious appetite for the truth, no matter what, and her disregard for the fact that what is true can also be uncomfortable, tiresome, compromising. She was engaged in a struggle against everything and everyone, but especially against the lies and materialism of that era, which she perceived as the darkness within America's soul, the nightmare that lay behind the 'dream'.

Her gaze turns towards the camera. Nancy becomes Nan, a Nan who does not yet recognize herself as such, but, in flight from the debilitating pressures of conformity and domesticity, shares all the common experiences of that decade. It was a kind of apprenticeship in freedom and suffering, in which she aban-doned home and parents for a communal life and a hippy interlude inspired by the 'Summer of Love'. Such a lifestyle, unfortunately, was a dream, but at least a dream imbued with liberation and vitality, earnestly pursued from day to day in the circle of her closest friends.

Some of the photographs from this time, along with the rest of her personal shots from the late 1960s and early 1970s, were later collected in *Dazzle bag*, and seen for the first time at her retrospective at New York's Whitney Museum of American Art in 1996. They show a young woman with loose, shoulder-length hair, looking thoughtful and slightly scared. The camera has already become part of her life, but on the sly, as it were, like an obsession whose nature is still unclear, and which is certainly without conscious goals. What matters to Goldin is to take photographs, and then more photographs; she is gripped by the need to hold on to what would otherwise disappear or be forgotten.

Her first attempts at a more thought-out photography (dating from her time at the Satya Community School in Lincoln, Massachusetts, where she became the school photographer, and later at the Boston College of Art), aspire to a sort of fashion-magazine glamour, and look more towards *Vogue* than to the classical traditions of photography. And yet, in spite of the traditional quality of the images, there is something excessive and dissonant about them. There is too much life, too much truth in them – consciously or unconsciously, they reject entirely the language of pretence or illusion. In short, these photographs have the roughness typical of reportage, but their context is different, more intimate and private, more participatory.

In this respect, Goldin has been linked to Diane Arbus and Larry Clark (particularly his book *Tulsa*, 1971), and she may be seen as being close to them in many ways, if only on a superficial level. But from the point of view of content, these artists are very different: there is no covert documentary or ideological purpose, no neo-realist mission in Goldin's work – not, at least, in these early

shots. There is, however, a pure determination to capture the moment, free from domination by abstract constructs of art.

During her time in Boston, Nan learned about life from life itself. Her chosen teachers were the city's drag queens, who captivated her and offered her an entrée into their parallel world. Over a long period of time she joined them in their daily lives at home, in bars and clubs, photographing them obsessively and sharing their secrets, their joys, their tragedies. They were the postmodern equivalent of a figure like the French hostess Madame Récamier; wise courtesans as far from the bland uniformity of the American dream and its materialism as they were from the country's politically militant underground. It was they who introduced Nan to the decadent sensuality of the *demi-monde* and to their culture of frivolity and excess, outside all conventions of logic or gender. The film director John Waters, himself then hardly out of his teens, was already working along the same lines, but his gift for black comedy would, to some extent, confine him to what was a very American and strongly ideological stereotype. Goldin's approach is more human and, genuinely, sad and truthful.

A self-portrait in colour, also from *Dazzle bag*, shows her in a red evening dress against a background of nightclub tables, holding a big reflex camera with a flash and looking like a genteel Weegee. She is no longer a hippy, but vaguely 'glam'. Her metamorphosis was complete (though she retained her deep, emotional interest in the soul of a person). What remains from this period and its early creative alliances – later called the 'Boston School', although none of those involved, from Philip-Lorca diCorcia to Jack Pierson or David Armstrong, ever considered the label very appropriate – is a handful of black-and-white photographs and some early experiments with colour – *Picnic on the Esplanade*,

1973 (pages 16–17); *CZ and Max on the beach*, 1976 (page 19); *Couple in bed*, 1977 (page 23) – which are now considered classic examples of her work.

In 1978 Nan went to London. There she heard the music of The Clash and The Sex Pistols, lived in squats and mixed with skinheads. Returning to the US, she moved to New York. Punk had already come and just as suddenly gone, and people were beginning to prefer the smooth decadence of the New York Dolls to the rawness of the Sex Pistols. Nan found a place on the Bowery, a stone's throw from William Burroughs' studio and John Giorno's Poetry System, and right opposite CBGB, at that time one of the most experimental and transgressive of the downtown clubs. She couldn't be said to be earning a living, either as a commercial photographer or as a young gallery artist (there were very few photography exhibitions in those days, fewer still of the 'new' photography). But paradoxically, her difficult financial situation – she was working as a nightclub bartender and was rarely in the darkroom – was to become the key to her future success.

As she had done as an art student in Boston, Nan exhibited her photographs in the form of slide shows, as a kind of private ritual within her four walls, or in clubs hospitable to experimentation, such as the Rafiks Underground Cinema, the Mudd Club and later Maggie Smith's Tin Pan Alley. Her 'family' and her first backers, in those days, were the people who frequented the clubs where she worked, the subculture of Times Square and the friends with whom she shared her small Bowery studio.

A number of people moved with her from Boston: Cookie Mueller, Sharon Niesp, Bruce Balboni and David Armstrong, a long-time friend, who was responsible –

at least as far as the name is concerned – for Nancy's transformation into Nan. They were to be her most frequent subjects during that period, along with numerous others – men and women, friends and lovers, or simply acquaintances who intrigued her in some way. They were the nucleus of what was later to become, after a long and exhausting process of reworking, *The Ballad of Sexual Dependency*, which is (and justly so) Nan Goldin's best-known work. Consisting of thousands of slides, *The Ballad* has accompanied her step by step from the early 1980s to the present day, and is constantly being added to and revised.

It is interesting that Goldin made her first appearance on the art scene with this disconcerting 'intervention' that caught people off-guard. *The Ballad* was entirely at odds with the prevailing theory and practice, which saw photography as the poor relation of painting. Her slide shows not only reasserted the serial nature of photography, but directly alluded to the medium's intangibility, making a revolutionary association between it and the language of cinema. This act of aesthetic subversion sprang more from choice and taste (Goldin is a great film buff) than from a deliberate tactical move in relation to the cultural environment and the art world. It is no coincidence that *The Ballad* received acclaim in Europe before it reached America, where attention was focused on the postmodern photography of Cindy Sherman and Laurie Simmons.

The individual shots making up *The Ballad* are like 'frames' (in the cinematic sense) belonging to a more complex narrative, arranged thematically – female nudes, images of women in front of a mirror, couples in bed, club scenes, sex etc. – but inseparable from the work's greater schema. The soundtrack,

a mix of classical, pop and rock music that is intentionally both ironic and sentimental – from Charles Aznavour to Boris Vian and Dean Martin – is an integral part of its concept, just as in Brecht's concept of 'epic theatre'. But the similarities with didactic theatre end there: Goldin's project is not to use photography to describe the outcast and oppressed, nor to preach some sort of redemption through art. Times Square is not the Berlin of the Weimar Republic. And in many respects, from the point of view of absolute truth, it is possible neither to make a critique nor to obtain redemption: This is the way things are, and we have to accept it and carry on. In the 1980s, Goldin's years of re-evaluation, bereavement and constant political activism on behalf of the gay movement, she saw her inner poetic articulated in fine detail in the spread of AIDS through American and European society.

The Cookie portfolio (1976–89), photographs dedicated to Goldin's friend Cookie Mueller who died of AIDS in 1989 at the age of forty, indicates the difference between the instinctive aesthetic sensibility of *The Ballad* and her more reflective and introspective mature work. It has a different perspective, more concerned with universality. In the Cookie portfolio we are offered once again a very intimate, personal story, in which even the most shocking details are tenderly conveyed. It is a piece of work unique in contemporary art, just as the human story it tells belongs uniquely to one individual, despite the fact that it could also stand as a representative tragedy for our times. It seemed to mark the end of an era; it is not that the past is denied, but everything is transformed by a different awareness of the truth of reality.

In the meantime, top galleries and museums had opened their doors, and Goldin enjoyed wide success. In 1991 she was awarded a study grant by DAAD (The

German Academic Exchange Service) and moved to Berlin, where she spent three years. During the first half of the 1990s, still only in her mid-thirties, she was well on the way to becoming a major figure in contemporary photography. She was invited to participate in the Biennale at the Whitney Museum, New York, in 1993 and again in 1995, and more opportunities to travel enabled her to add several new series of photographs, taken in Europe and the Far East, to her personal collection.

Some of Goldin's photographs, despite being taken out of context, have become touchstones of the contemporary visual imagination, avidly collected all over the world and assimilated into the mainstream – copied, manipulated and imitated *ad infinitum* in books, newspapers and magazines. It is difficult to be certain, at this point, whether an individual vision created a taste among the public, or whether it was more the case that a public mood eventually legitimized an individual response.

Nowadays, when debates on art and photography and the single versus the multiple work seem like hangovers from the past, and we have gone from a situation where too little photography was exhibited to one where there is too much (and that often mediocre) Goldin is rediscovering a kind of new visual classicism, but one expressed in ever more complex narrative patterns.

Paradoxically, one could say that the essence of her activity in the past few years has been to turn the photographic portfolio into a type of sculpture. The three-dimensional quality of sculpture allows us to circulate freely around the work, appreciating all its different angles and the way that the subject captures the light. Goldin's 'grids' (*Tokyo Love grid*, 1994; *Positive grid*, 2000; *Maternity*

*grid*, 2001) – sets of images assembled according to a theme or organized in a narrative sequence – reflect the same need to make the work more physical while attempting to exhaust all the possibilities of a particular viewpoint.

The raw material of the work remains the same, distilled day by day from hundreds of private images in an unceasing process of selection and revision. Goldin's archive contains a wealth of shots that are outstanding, but for one reason or another have never seen the light of day. They represent far more than mere approximations to, or versions of, those images that go on to be famous. Ever the perfectionist, Goldin will discard a wonderful photograph for the slightest reason. She has the deepest respect for her friends' beauty and is careful to avoid inappropriate or ungenerous images. And she doesn't easily make mistakes. She is helped in this by her disconcertingly acute visual memory; she can recall an image taken years ago and distinguish it from hundreds of others like it. The 'heaviness' of the grids (ie. their permanence as physical objects) represents a perfect counterbalance to the 'lightness' (ephemerality) of the slide shows, of which there have been a number of other interesting examples – one based on self-portraiture, *All By Myself*, 1994; one on the drag queens, *The Other Side*, 1994; and *Tokyo Spring Fever*, 1995.

Works that stand mid-way between these two extremes are Goldin's latest installations. These include one entitled *Thanksgiving*, with a distinctly retrospective flavour. It comprised more than 100 photographs from the 1970s to the present day and entirely covered the gallery walls. It was shown in London in 1999 and is now in the Saatchi Collection. Another is the very recent *Suite 22*, a detailed reconstruction of the fifty-two days Goldin spent in New York's Roosevelt Hospital in the summer of 2000.

Goldin's growing interest in landscape and still life (work she kept secret until it was shown at the Whitney retrospective) in its purely pictorial aspects — *Volcano at dawn*, 1996 (pages 94–5); *Breakfast in bed*, 1996 (page 93) — stimulated by her increasing contact with a European sense of history and the past, has resulted in a series of photographs that seems out of keeping with the Goldin we all thought we knew. From having been mere asides in a larger narrative, they gradually became a thematic strand in themselves, similar to what Goldin had done earlier in her series of hotel-room photographs (*Vakat*, 1993). Looked at carefully, each of them works as a portrait, linked in a somewhat obscure and esoteric way with her usual overriding impulse, which is to portray the self, using the self as medium.

In the meantime, new friends have joined Nan's extended family, while others have left it. Paris, Switzerland and Italy have gradually replaced Times Square and the Bowery as settings for her work. There are obvious personal reasons for this — mainly the loss of so many of her New York friends to AIDS. But also perhaps, at a deeper level, Goldin feels a close intellectual and artistic connection with Europe.

The recent work she has made in Paris and the United States — *Joana laughing*, 1999 (page 117); *Joana and Aurèle making out*, 1999 (page 121); *French family before the bath*, 2000 (page 123); *Joana's back in the doorway at the Châteauneuf-de-Gadagne*, 2000 (page 125) — all devoted to an artist couple, Aurèle and Joana, takes us right back to the days of *The Ballad* as far as the surface perfection of the shot is concerned, but forces us to think differently about point of view, and the psychological tension with which the images are imbued. It suggests a wish to make friendship and intimacy the means of

rebuilding a fragmented world. It is an exclusive friendship, not played out in public places or at gatherings to which others are admitted, but entirely focused on the everyday realities of domestic life. This different viewpoint has effected a change in her handling of light in her photographs, from the claustrophobic hues of *The Ballad* to softer and brighter colours.

There is, then, little to support the position of those who would still like to describe Nan Goldin as some sort of 'dark lady' or as a poet of the lower depths. Oddly enough, her current work includes more images with a religious background – such as *Fatima candles*, 1998 (page 99) – than a club setting. But this is yet another purely human development, springing from the normal dialectical relationship between art and life, and from Goldin's thirst for truth, above all things. This is where her strength lies, in her ability to disappear completely behind the lens, while at the same time powerfully communicating her presence as a compassionate eye, the key to the ultimate meaning of the story.

Every one of Goldin's photographs, today just as much as twenty years ago, is like a window opening on a labyrinthine body of stories – some happy, some tragic – in which drugs, homosexuality, excess and transvestism are secondary elements, even if not historically or sociologically so. Goldin's critics and interpreters have focused on these themes, but to the artist they are contingent accidents rather than essential substance, simply not integral to her poetic. Goldin is not a judgemental commentator, but rather a reporter who accepts things around her as they are. And it is precisely the fact that Goldin takes as her starting point the particularity of a given image and from it constructs something universal that captures our attention. We are all, after

our own fashion, part of Nan Goldin's story. When we look at the photographs of her friends or lovers, the places she has lived in or visited, it is almost as if a small piece of our own past were falling back into place, as we substitute other faces for these faces, and supply other, different histories for these narratives.

**Picnic on the Esplanade, Boston, USA, 1973.** This photograph, among the first Goldin made in colour, shows many of the features that made her one of the first and foremost exponents of the snapshot aesthetic. This Easter picnic by the river in Boston shows Goldin's 'family' at that time, one of the happiest periods in her life. She was living with a group of drag queens, her heroines, and had already amassed a huge body of black-and-white photographs of them. It shows her lifelong obsession with social rituals and the pleasures of communal life. Over time she would lose many people in this group to AIDS and drug addiction.

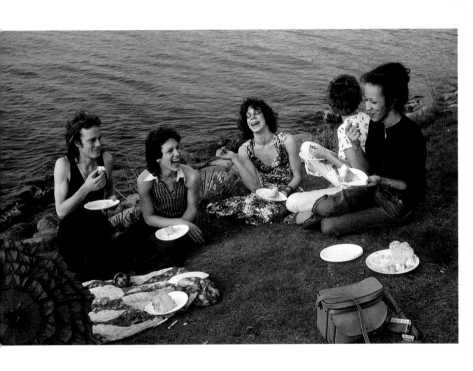

**CZ and Max on the beach, Truro, Massachusetts, USA, 1976.** Of all the colour photographs Goldin took in the 1970s, this is probably the most polished and richly evocative. Full of details that give it movement, it plays intelligently with the unusual angle and saturated colours; its equilibrium makes it a perfect example of the snapshot.

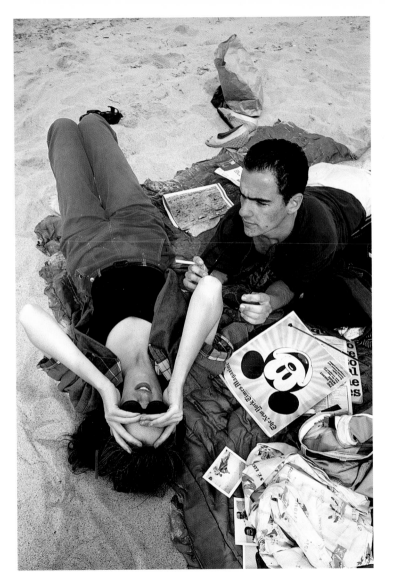

**Ryan in the tub, Provincetown, Massachusetts, USA, 1976.** Women in water recur in Goldin's photographs, from her earliest to her most recent work. Goldin did not consciously choose this as a theme to begin with. She has always been and still is drawn to water, as can be seen in her later landscape and portrait work. It can be read as evocative of the womb or sleep, or birth and death. This image of a friend and roommate exhibits the extreme androgyny which is typical of her work.

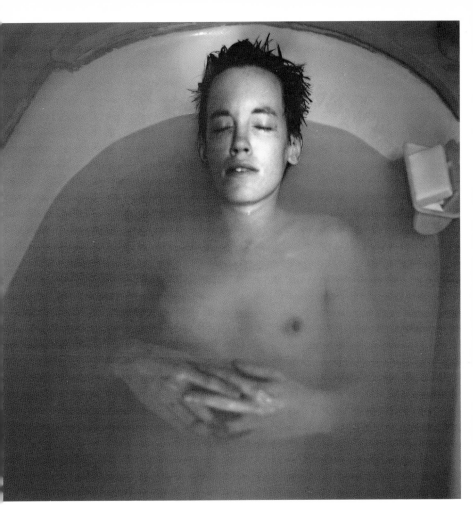

**Couple in bed, Chicago, USA, 1977.** Goldin is often present at very intimate moments in the lives of her close friends. The trust they develop allows her to capture what is usually kept private and to make it public. This has always been one of her concerns — pushing the boundaries of social taboos. This image seems to express what Goldin perceives as the peculiar estrangement and alienation that often occurs after sex between men and women. Within intimacy there is often a great distance — a paradox that Goldin daringly explored in her best-known work, *The Ballad of Sexual Dependency*.

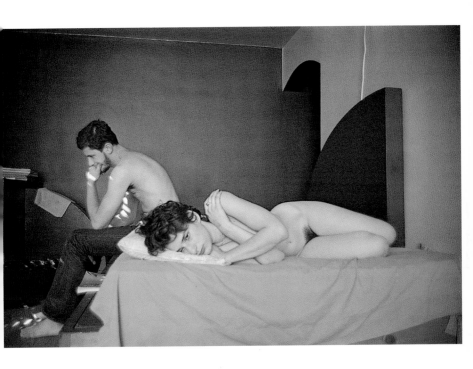

**Skinhead having sex, London, England, 1978.** Goldin is famous for her explicit portrayal of the erotic, but her work is never pornographic or sensationalist. She has been one of the most outspoken women artists on sexuality, photographing it in all its forms and thereby stepping into the previously exclusive domain of male photographers. Goldin sees sex, first and foremost, as a mirror for the soul and thus part of a deeper and more complex relationship, linked to the pains and joys of love and friendship. That idea is clearly present in the abstract schema of this photograph, exclusively concerned with the forms of the two bodies joined together.

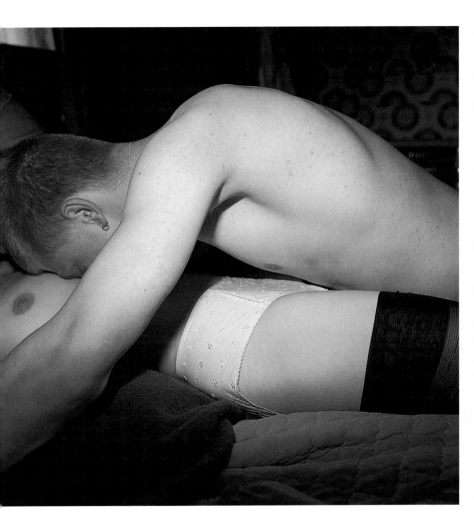

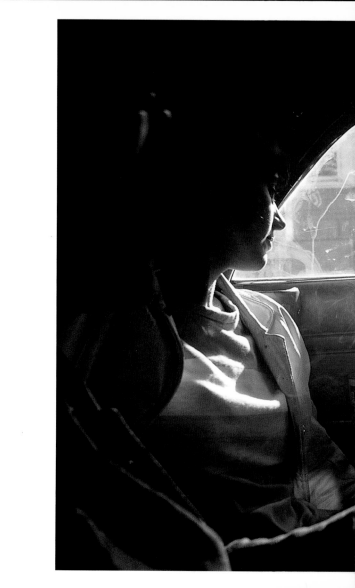

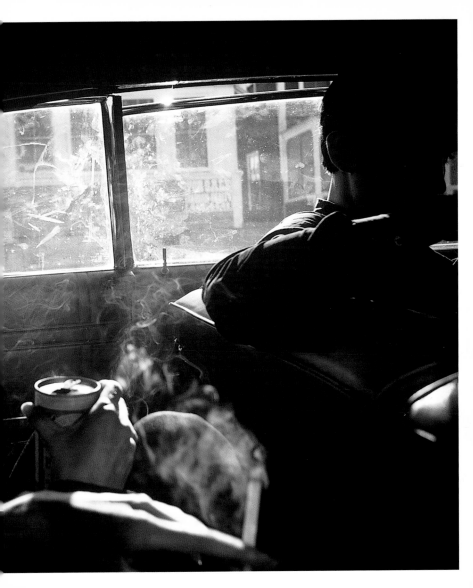

**(previous page) Smokey car, New Hampshire, USA, 1979.** Inconsequential daily events, situations with no particular story behind them and the anonymity of repeated gestures (like smoking a cigarette or drinking a beer) often catch Goldin's eye. This shot turns on the contrasts between light and shade, interior and exterior. It shows a moment suspended in time and captures, as many of her images do, a sense of solitude and estrangement, even within a pleasure-filled situation.

**Anthony by the sea, Brighton, England, 1979.** Another recurrent and subconscious motif in Goldin's work is that of people gazing through windows, representing simultaneously a physical and psychological interior and exterior. Here she captures two separate realities — the melancholic aspect of the man and the sea. It is one of her most classical and best-known photographs, reflecting the onset of a mature, fulfilled vision.

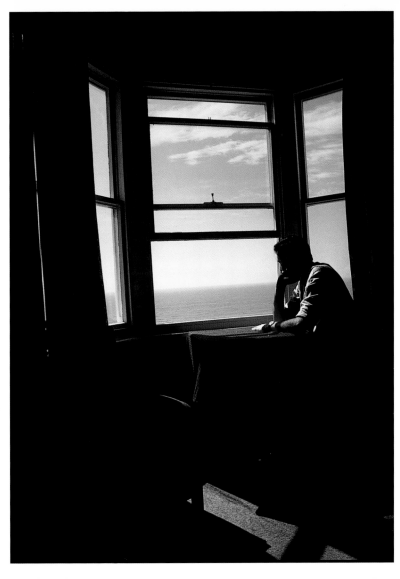

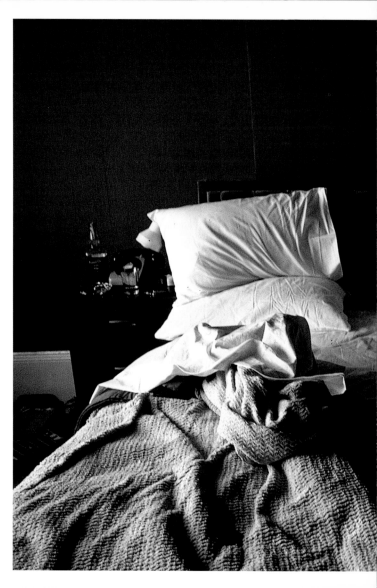

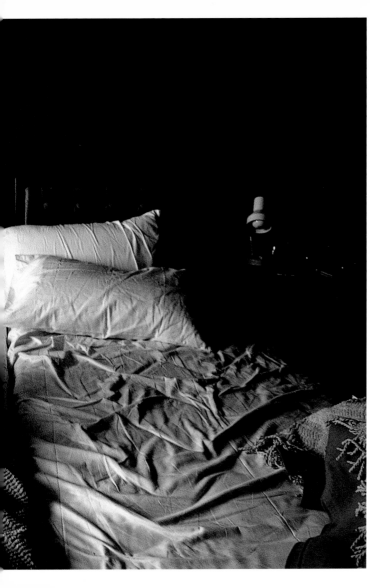

**(previous page) Empty beds, Boston, USA, 1979.** This image was taken right after lovemaking. For Goldin, a picture of a room is a form of portraiture. Empty beds, whether unmade or made, squalid or luxurious, are a recurrent subject in her work. They are part of one of her major obsessions – the need to remember places as well as people. They suggest constant departures and loss, and the difficulty of finding a fixed place on one's own journey. The same ambiguous feeling runs through the long series of pictures of hotel rooms, published in book form as *Vakat* (in collaboration with Joachim Sartorius, 1993).

**Trixie on the cot, New York City, USA, 1979.** Among the photographs taken at parties that are scattered throughout *The Ballad* like a leitmotif, this is certainly one of the most evocative. Being alone in a crowd, and sadness as the inevitable antithesis of the exhilaration of a party, are hallmarks of this period, combining a sense of the excitement of communal life with an awareness of individual destiny. A delicate melancholy pervades many of the pictures, even the most joyously transgressive.

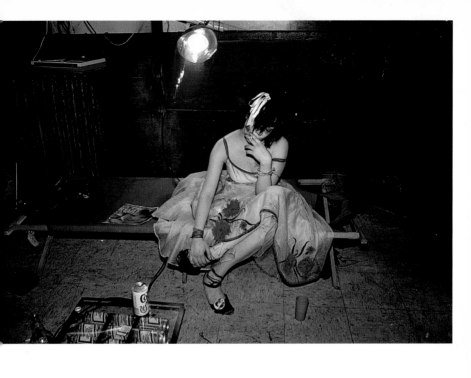

**The Hug, New York City, USA, 1980**. This photograph, justly one of the mos
iconic from Goldin's early work, is often mentioned as a small masterpiece o
style and composition. It embodies the very essence of Goldin's most famou
slide show and first book, *The Ballad of Sexual Dependency*. The man's grip 
tender but fierce, almost as if the couple were engaged in a struggle, and seem
to represent the pull between autonomy and dependency that is inherent in mos
romantic relationships.

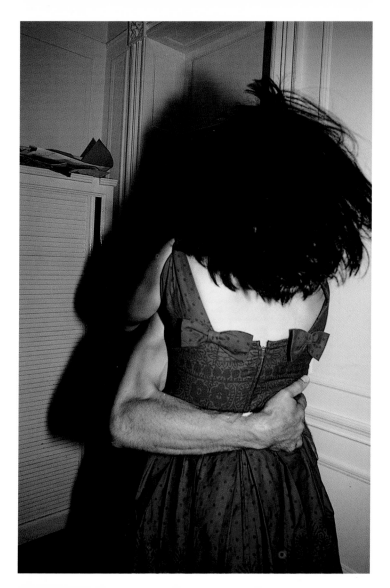

**Brian on the phone, New York City, USA, 1981**. Brian and Nan were a couple for about three years and he is one of her most photographed subjects. It was a tough time for Nan, to which many of the photographs from the period attest with brutal directness. The story of their relationship, told in a number of exemplary photographs – including *Nan and Brian in Bed*, 1983 (page 41) – is a melodrama marked more strongly by a sense of the impossibility of communication than by the idea of love. It was a kind of macabre and desperate time, of harrowing emotional intensity, shot through with drug-taking.

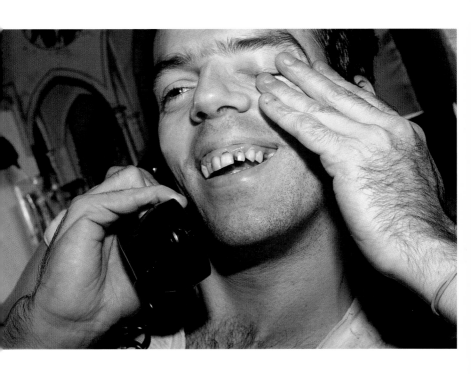

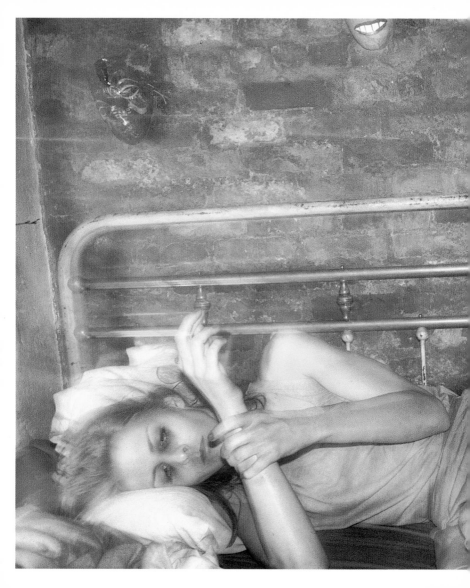

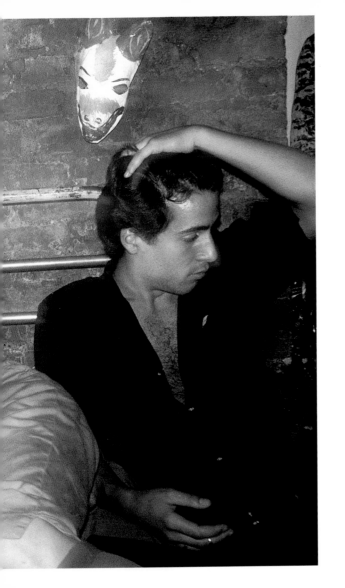

(previous page) **Greer and Robert on the bed, New York City, USA, 1982.** This is one of Goldin's favourite images and is typical of the intensely dramatic mood of many of the images in *The Ballad*. It is particularly poignant because of Greer's unrequited desire for Robert. The light surrounding her body gives her an ethereal, other-wordly quality and is a brilliant evocation of the alienation between the genders. Greer, an East Village artist, was close to Goldin for many years, until her premature death in Chicago in 1999. One of Nan's first 'grids' (*Greer grid*, 1999) is devoted to her, telling the story of her short life and her transformation from a man into a woman.

**Nan and Brian in bed, New York City, USA, 1983.** This photograph appears on the cover of the published version of *The Ballad of Sexual Dependency* and is a distillation of the poetics of the whole cycle. It succeeds perfectly in portraying an intimate relationship, two solitary existences and the perpetual dialectic of the sexes. Even the play of light augments the idea of separation and difference. The ambivalence in Goldin's expression – desiring further contact and yet fearful – indicates what is to come in their relationship. Taken with a cable release, Goldin had no idea how revealing the picture was until it was developed.

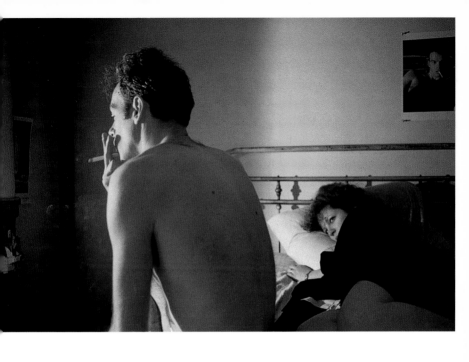

**Cookie at Tin Pan Alley, New York City, USA, 1983.** Cookie Mueller, actress, poet and cultural activist on the New York underground scene of the early 1980s, was Nan's closest friend for many years, perhaps even her muse and guru. This image is part of the famous Cookie portfolio, in which Nan tells her friend's story, from their first meeting in Provincetown in 1976 to her death from AIDS in November 1989. Here, Cookie is at Tin Pan Alley, the club where Goldin worked for a time as a bartender and where she often presented her early work in the form of slide shows.

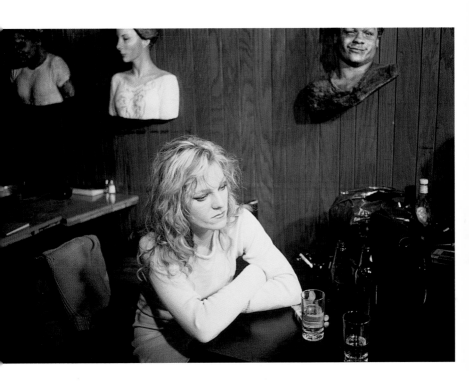

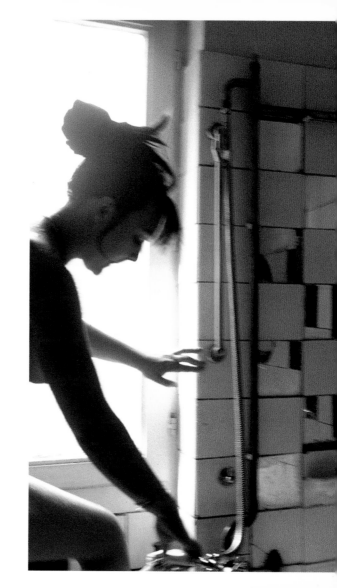

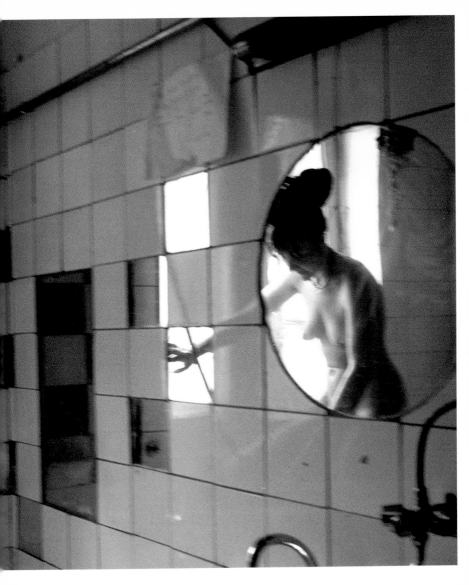

(previous page) **Käthe in the tub, Berlin, Germany, 1984.** Käthe is a musicia whom Goldin met when she first lived in Germany. In subject matter the image related to the many other photographs of women in bathrooms or reflected i mirrors. It was no accident that the mirror was also the central motif of he mid-career retrospective at New York's Whitney Museum in 1996 and entitled, i the words of Lou Reed, 'I'll Be Your Mirror'.

**Nan one month after being battered, New York City, USA, 1984.** This photograp shows the aftermath of Goldin's stormy relationship with Brian and is one c her most unsparing self-portraits. She has always seen it as a kind of warnin against falling into the same trap again or against colouring memories wit nostalgia. The injuries she received almost cost her the sight in her left eye. I terms of *The Ballad*'s symbolism, it marks the end of a beautiful dream and th beginning of a period of complete transformation.

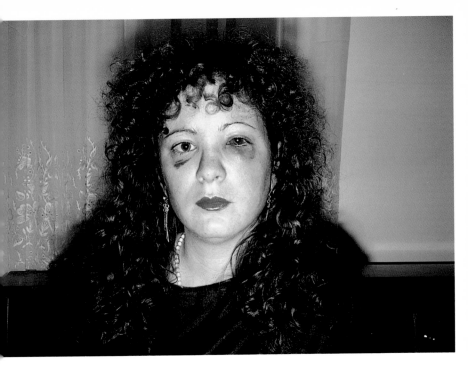

**Suzanne crying, New York City, USA, 1985.** A large proportion of Nan Goldin' images show moments of dejection or despondency. Tears, like laughter, are a inescapable part of human life. Goldin's work is driven by empathy, by the desir to share the other's experience. Her primary concern is with truth, with n adornment or dramatization, even if it is distressing. Suzanne, caught at thi moment of despair, is one of Goldin's oldest friends, with whom she shared no only her time in Boston, but also her very difficult early years in New York. Thi photograph was once referred to in a review as 'the closest a human being coul get to another'.

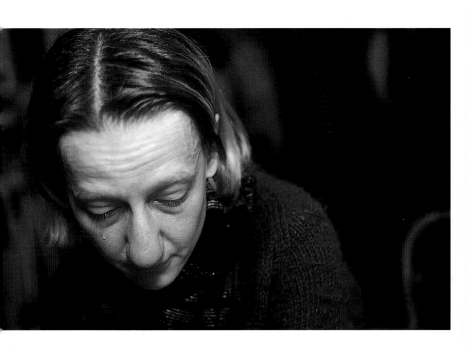

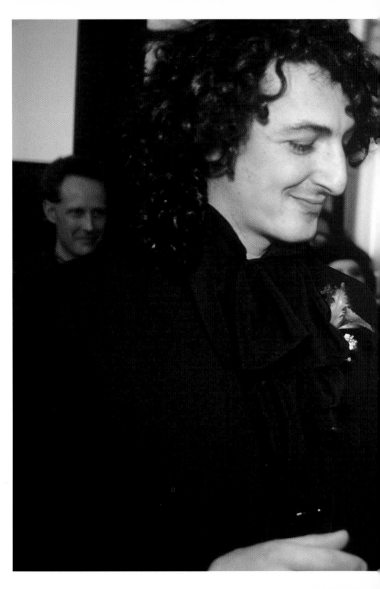

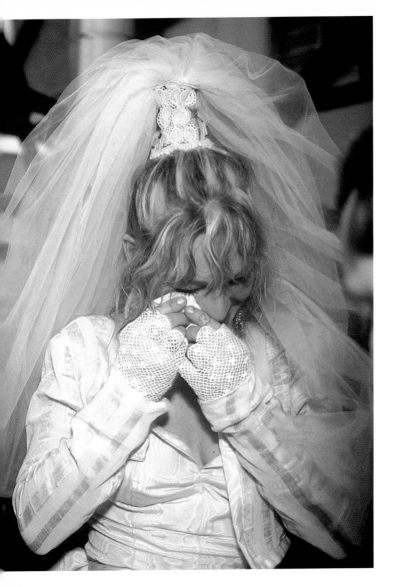

**(previous page) Cookie and Vittorio's wedding, New York City, USA, 1986**
In 1986, Cookie married Vittorio Scarpati, a Neapolitan artist living in New York. It was Vittorio who introduced Goldin to the cosmopolitan world of Positano, a small town on Italy's Amalfi Coast, where they all spent part of the summer of that year together. Vittorio, too, died of AIDS in 1989, a few months before Cookie. Nan not only devoted some of the photographs in the Cookie portfolio to this tragic event, but also the first section of her book on Naples, *Ten Years After* (1996).

**Rise and Monty kissing, New York City, USA, 1988.** This image is another small masterpiece of visual balance and tension, and demonstrates Goldin's extraordinary capacity to capture the power of sensuality. It shows a moment at which the differences between the sexes seem to vanish in erotic communion. But the artist's gaze, while complicit, nevertheless communicates a certain discomfort, as though the erotic encounter was somehow provisional, or doomed to failure.

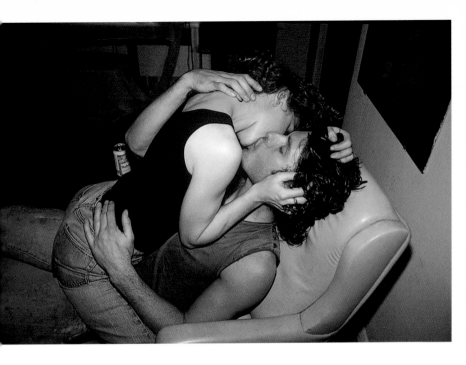

**Sharon nursing Cookie on her bed, Provincetown, Massachusetts, USA, 198**
Like Cookie, Sharon was for many years a familiar subject in Goldin's photo
graphy. Her masculine beauty often made a perfect counterbalance to Cookie
exuberant and extremely feminine sensuality. This photograph, from the Cook
portfolio, catches these ex-lovers and friends at a tragic time, marked by th
progress of the illness that in a matter of months would cut short Cookie's life.
was Sharon who would nurse Cookie through the months when she could n
longer even speak, even though the photograph on the wall testifies to Cookie
marriage to a man, after eight years as Sharon's lover.

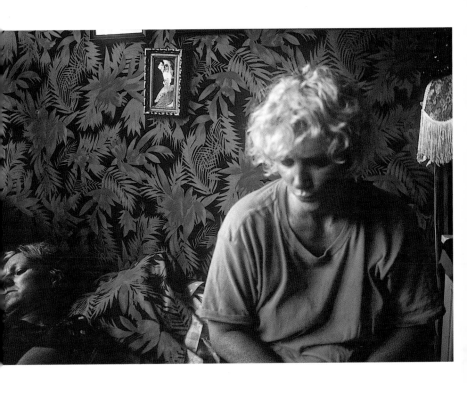

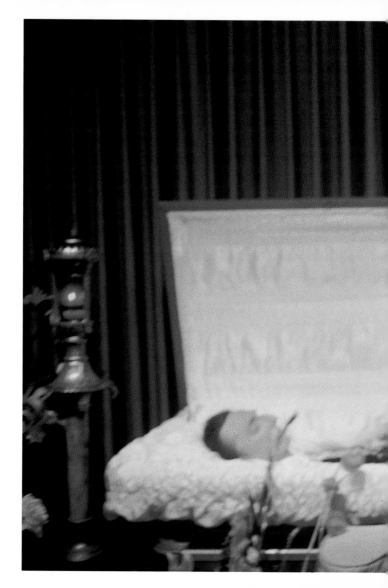

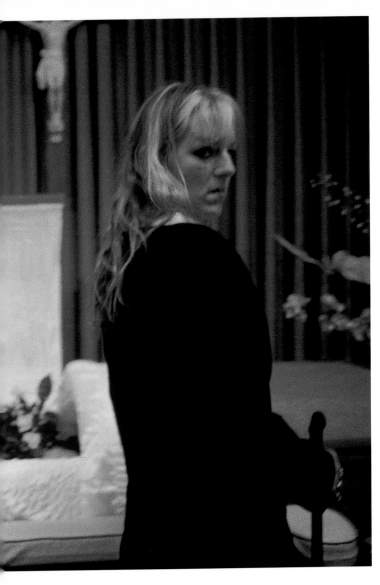

(previous page) **Cookie at Vittorio's casket, New York City, USA, 1989.** The deaths of Vittorio and Cookie, only months apart, affected Goldin so deeply that they caused a radical change in the way she made photographs. The end of an era marked by grief, loss and profound changes in behaviour saw the beginning of a more thoughtful, introspective approach. Goldin was, however, still driven by the political desire to use art to put on record certain social and inter personal phenomena. This photograph of Vittorio's funeral is like a last act of love for all dead friends. It is a companion piece to others that are also full of raw pain, like those dealing with the deaths of Cookie, Gilles and Half.

**Self-portrait writing in my diary, Boston, Massachusetts, USA, 1989.** This photograph, taken in the privacy of the bedroom, catches the photographer in a pose utterly familiar to those who know her. Like photography, writing is, for Goldin, a continual activity, and she has filled dozens of notebooks, all exactly the same size, shape and colour. They represent an urge to record and remember that has always been with her and often provide a contrast to, or a commentary on, her work as a photographer. The shadow that animates this shot expresses with great precision the relationship between remembrance and personal history.

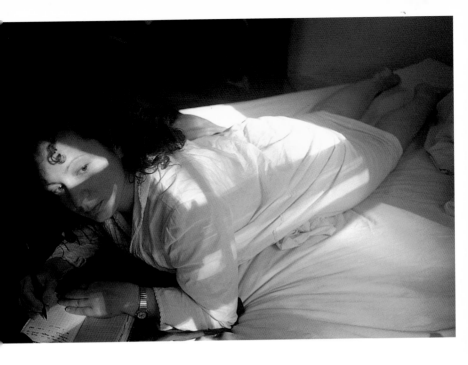

**Siobhan in the shower, New York City, USA, 1991.** Some of Nan Goldin's most tender and beautiful images are devoted to Siobhan, her friend and partner for a number of years in the early 1990s. They are a tribute to love between women, in a more comforting and gentle key than the stories told in *The Ballad.* These photographs emphasize complicity, free of the antagonism often found in heterosexual love.

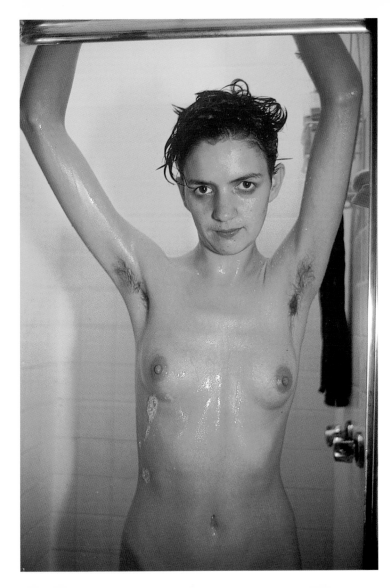

**Gina at Bruce's dinner party, New York City, USA, 1991.** Goldin and her friend including Gina, used to meet at Bruce's house for dinner and the photographe would show slides of everyone present. In this picture, Gina is waiting for second helping of meatballs. The image has been much acclaimed for its form aspects and intense colours, yet nothing has been staged or art-directed. does, however, have a certain classicism, reinforced by the Caravaggio hangin on the wall.

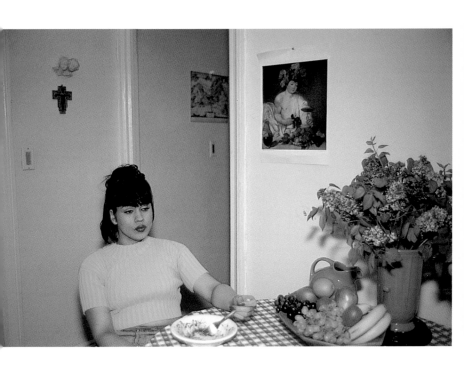

**Joey at the Love Ball, New York City, USA, 1991.** Joey is one of Goldin's olde
and closest friends and has been an inspiration both for her photography ar
for her aesthetic in general. Her images of Joey pay tribute to her beauty ar
to a glamour that is almost obsolete today. Many of these images were publish
in *The Other Side* (1993), named after a nightclub in Boston famous for i
transsexual shows and one of Goldin's favourite haunts when she was an a
student. This photograph was taken outside the Roseland Ballroom on the nig
of one of the historic Love Balls, among the first in a series of events to rai
money for AIDS research. Joey designed the wig and gown herself, based on t
film *Barry Lyndon*.

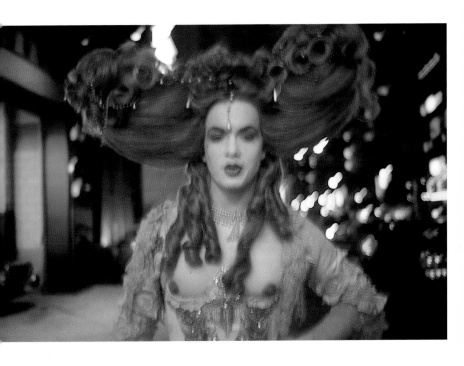

**Jimmy Paulette and Taboo! in the bathroom, New York City, USA, 1991.** Jimm
Paulette, Taboo!, Cody, Misty, Guy and other drag queens are the subjects
some of Goldin's best-known photographs, taken in New York, Paris and Berl
between 1990 and 1992. This one in particular, chosen for the cover of *Th
Other Side*, is among those most frequently reproduced and, consequently, mo
popular. The drag queens series has captured the imagination of the art publi
even though it represents only a limited part of Goldin's work.

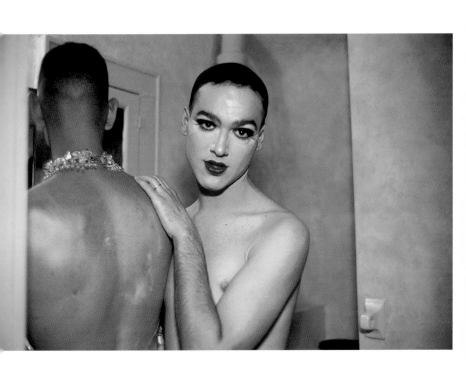

**Misty and Jimmy Paulette in a taxi, New York City, USA, 1991**. Goldin's politic commitment to civil rights has led to her involvement in initiatives and demonstrations on behalf of the gay community and people with AIDS. This photograp was taken on the way to the 1991 New York gay parade and is one of the mo copied of Goldin's images. It has turned up in all kinds of commercial contexts, spite of the fact that is was made as an intimate and real image.

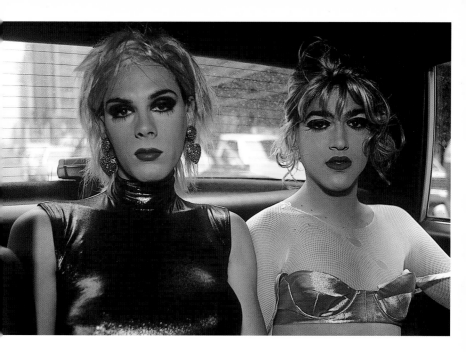

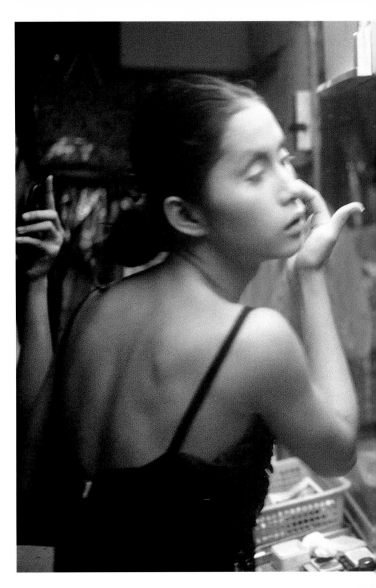

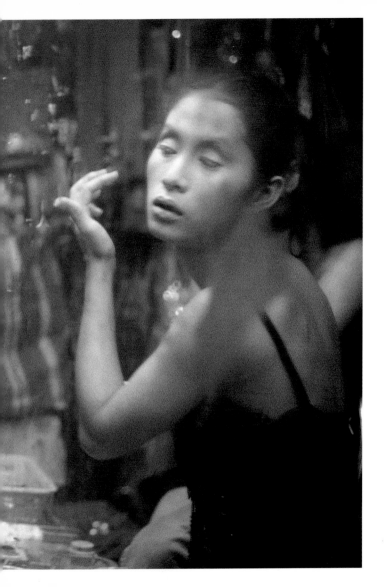

(previous page) **C putting on her make-up at Second Tip, Bangkok, Thailan**
**1992.** This portrait belongs to a short cycle of work devoted to erotic shows
the Far East and has thematic links with contemporary Japanese photograph
The Second Tip is a nightclub in Bangkok's red-light district, famous for it
transvestites and male prostitutes. Along with So, Yogo and Toon, who also fea
ture in a short series of photographs on the 'mirror' theme, C was one of th
club's main attractions. Although they spoke no common language, Nan becam
close friends with them for the month she was in Bangkok. When she sent copie
of *The Other Side*, her book devoted to drag queens, to the Second Tip, sh
received loving letters from the queens and their Madam.

**Self-portrait on the train, Germany, 1992.** This self-portrait was used on th
cover of the catalogue for Goldin's major retrospective at the Whitney Museu
in 1996. It achieves its striking effect through its balanced composition ar
colour, which makes a connection between the photographer's face and th
landscape seen from the window of the train. It is a very truthful portrait of th
artist, organized symbolically around the way she is gazing abstractedly into th
distance. It is also a metaphor for her emotional alienation from New Yor
and her search for a home in Europe, with which she felt a deep intellectual ar
artistic connection.

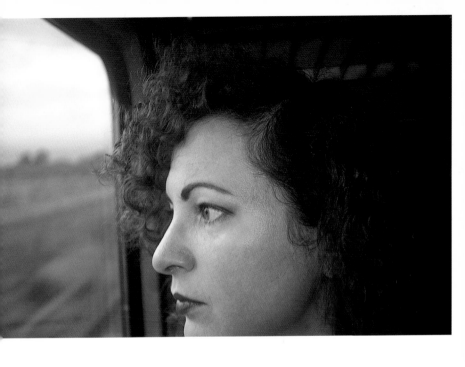

**David in Bed, Leipzig, Germany, 1992**. The photographer David Armstrong i Goldin's oldest friend. She photographed him as a teenager in the 1970s an her career could be said to have run parallel to his, different though they are In 1994 they jointly produced *Double Life*, a book documenting their person and artistic association over more than twenty years. Among the many pho tographs in which he appears, this one in particular underlines the closenes of life spent together for long periods of time, first when they shared a Bower studio, then on their extensive travels. He curated Goldin's retrospective at th Whitney Museum, New York, in 1996, and its European tour the following year.

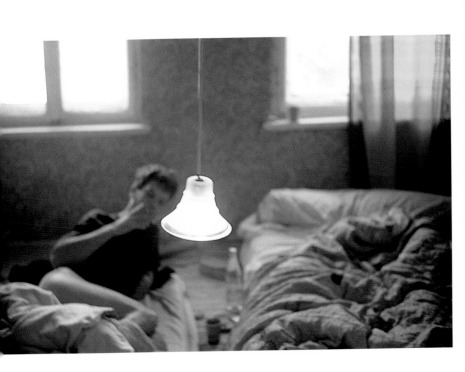

**Gilles and Gotscho embracing, Paris, France, 1992.** Along with the Cookie portfolio, Goldin's series of photographs on Gilles and Gotscho's relationship undeniably one of her most touching and sombre works. Gilles, the owner of the Paris gallery where Goldin exhibited, and one of the first people to support her work, died of AIDS in 1992. With great compassion, she records his final months, from the appearance of his illness to his death in hospital. Gotscho, his partner, was beside him throughout. This shot, which is like a photographic analogue of Michelangelo's *Piéta*, is rightly considered to be one of Goldin's most important works, and one of the most powerful documents to deal with the tragedy of AIDS.

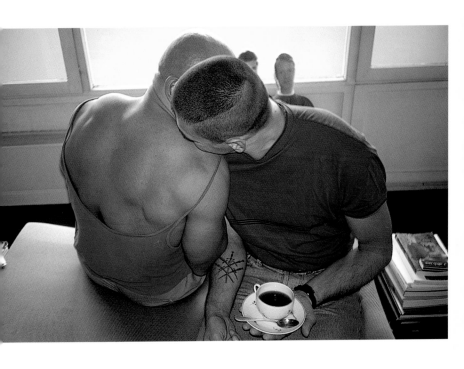

**Gotscho kissing Gilles, Paris, France, 1993**. The tenderness of this last leave-taking is brought out by the contrast between the two men, one consumed by his illness, the other in robust good health. Gotscho, a Parisian artist, gave his own first-person account of this brief moment with great feeling and delicacy in Goldin's short film for the BBC, *I'll Be Your Mirror*.

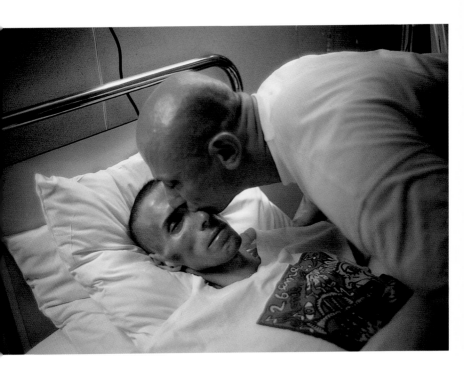

**Gilles' arm, Paris, France, 1993**. This photograph, an immensely powerf
*memento mori*, symbolically ends the story of Gilles and Gotscho. The dreadfu
thin arm resting limply on hospital bedclothes, and the composed dignity
death, give this a resonance that goes beyond the individual story it tells. *H*
*grid,* a short cycle of photographs from a slightly later date on the death fr
AIDS of another old friend, Half, has a similar intensity.

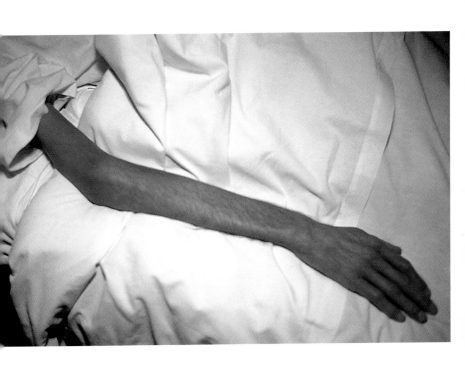

**Geno in the lake, Bavaria, Germany, 1994**. This portrait of Geno, a Berlin actress who appears in many of Goldin's photographs, carries pictorial echoes of Impressionism. In many respects, it foreshadows Goldin's more recent work which can be very raw, but sometimes has exquisite touches of sentiment and romance. Since this time, Goldin has become increasingly interested in photographing friends in nature.

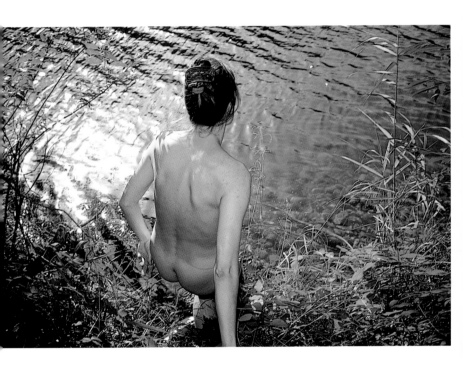

**Honda brothers in cherry blossom storm, Tokyo, Japan, 1994.** During the 1990s Goldin made several visits to Japan, where her work is well known and widely appreciated. A variety of photographic work records this period; some of depicting club life, some more private and personal. The shower of cherry blossom, a symbol of the brevity and transience of beauty, adds movement to the scene, turning this portrait of the Honda brothers into an image in which the subject and the setting are successfully balanced. It is a photograph on the theme of spring in Japan, but one that takes on qualities of abstract painting and kinetic experimentation.

**Kathleen at the Bowery Bar, New York, 1995.** Kathleen is a New York arti⟨
who has been Goldin's close friend since the late 1980s. In the context of th⟨
portraits of women, she represents a type of beauty of another age, full ⟨
pronounced, vibrant sensitivity. It is her combination of wildness and fragili⟨
that has made her a frequent subject of Goldin, who tries to capture her melar⟨
cholic features and gentle sensuality.

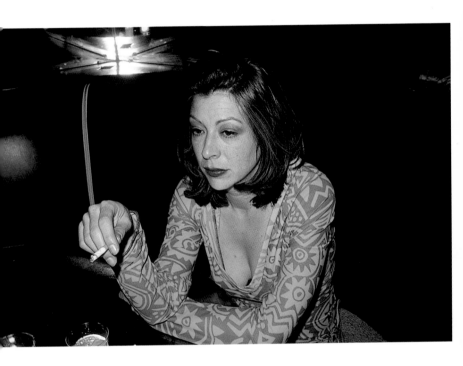

**Bruce in the smoke, Pozzuoli, Italy, 1995.** Since 1974 Bruce has been on of the most frequent subjects of Goldin's photographs. Along with Dav Armstrong, he represents a cornerstone of her personal life, a friendship tha has lasted through the decades. In this shot he is on the *solfatara*, or sulphu volcano, at Pozzuoli, near Naples, when Nan's first Italian exhibition was preparation. The photograph, with its attractive light and soft tones, forms pa of a longer Italian cycle (reproduced in *Ten Years After*) and was also use recently in *Positive grid* (2000), which deals with HIV and seropositivity. Goldin, it also represents Hell and the devilish side of Bruce, as well as th spirituality of fire and a sense of deep solitude and emptiness.

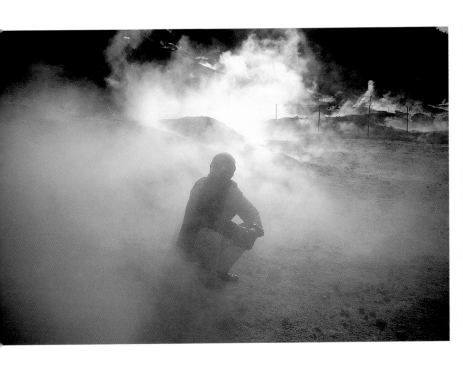

**Pawal laughing on the beach in winter, Positano, Italy, 1996**. This photogra
dates from Nan Goldin's return to Positano, where ten years earlier she h
spent a long holiday with Cookie Mueller and Vittorio Scarpati. Pawel has ju
come out of the freezing winter sea. It is a sunny, joyful image, a perfect reco
of a return to the past, but a past seen with a new vision. This new vision li
behind many of the photographs in the Italian cycle.

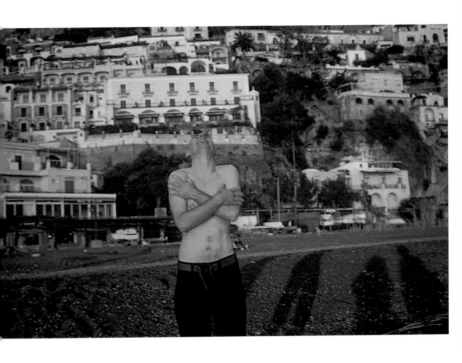

**Breakfast in bed, Hotel Torre di Bellosguardo, Florence, Italy, 1996.** Of all the still lifes made by Goldin in recent years, this is one of the most accomplished, in terms both of colour and compositional rigour. Given the setting, it could also be seen as one of the many photographs she has made of hotel interiors and the private rituals that are performed in them. It is a memory of intimacy as well as a still life.

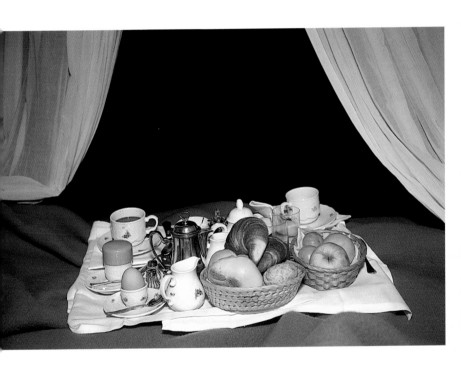

**Volcano at dawn, Stromboli, Italy, 1996.** This view of the volcano of Strombo taken as the hydrofoil is approaching the island's port, is one of Goldin's mc magical and tender landscape photographs. There is a paradoxical seren within the violence of the active volcano. It is typical of the melancha nostalgic character of the whole Italian cycle. The same dominant blue tor are found in many other photographs from this period and suggest a renew contact with nature and its colour patterns. Some of Goldin's most rece photographs taken on the islands off the coast of Tuscany or in the Caribbe have a similar quality.

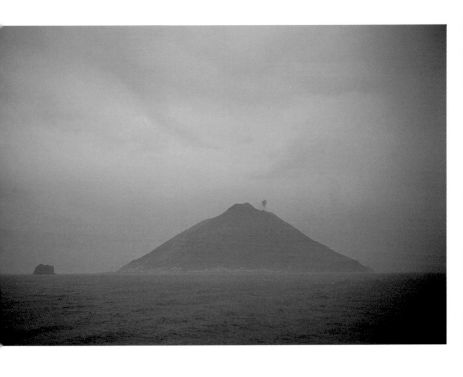

**Lil laughing, Swampscott, Massachusetts, USA, 1996.** Lili is Goldin's moth
and she has photographed her on various occasions over the years, alone
with her husband. This photograph, in which the subject is especially happy a
exuberant, is part of a longer series of images with an informal, domes
setting, notably those showing Goldin's nephew Simon, the son of her eld
brother Stephen. This image, in particular, testifies to an entirely new sense
the beauty of old age, caught here in what is almost a return to the high spir
of adolescence, and to Nan's continued intimacy with her parents who are n
in their eighties.

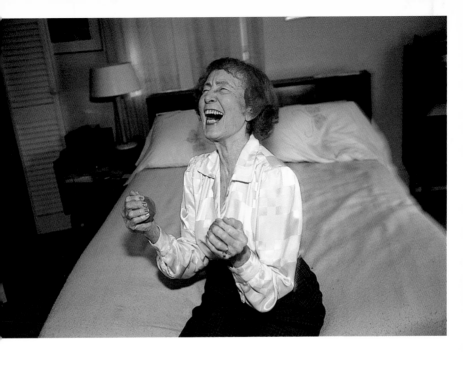

**Fatima candles, Portugal, 1998.** This photograph is an expression of Goldir
interest in religious subjects, or more generally, in a particular kind of spirit
ality. Taken inside the church of the Madonna of Fatima in Portugal, it w
intended as a tribute to her dead friends. (Whenever Nan goes into a church s
lights candles for her friends with AIDS, believing it helps keep them alive.)
has often been exhibited in settings with a religious significance (such as t
Palace of the Popes, Avignon), and as part of *Positive grid* (2000).

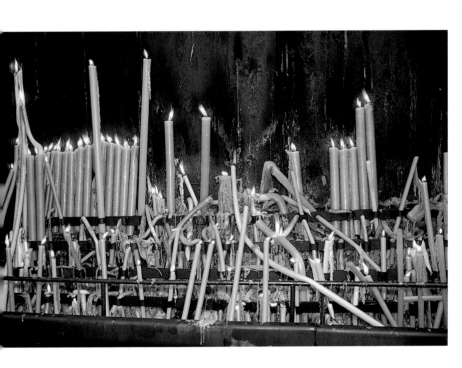

**Guido on the dock, Venice, Italy, 1998.** This picture of one of Nan's Italian friends exemplifies her new interest in the contrast between figure and landscape, and her preference for a softer, more reflective mood. It does not belong to any specific cycle, but has strong connections with a whole series of outdoor shots, in which natural light is used in a particular way and the human body presented as a purely abstract form, such as *Gigi in the blue grotto with light* 1997 (pages 102–3).

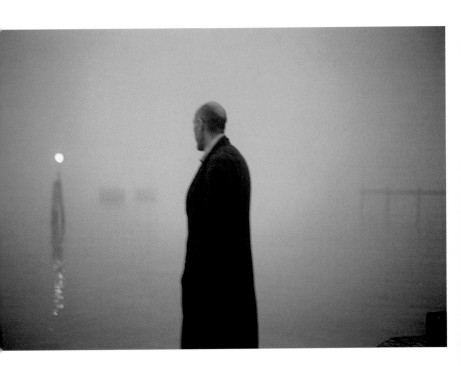

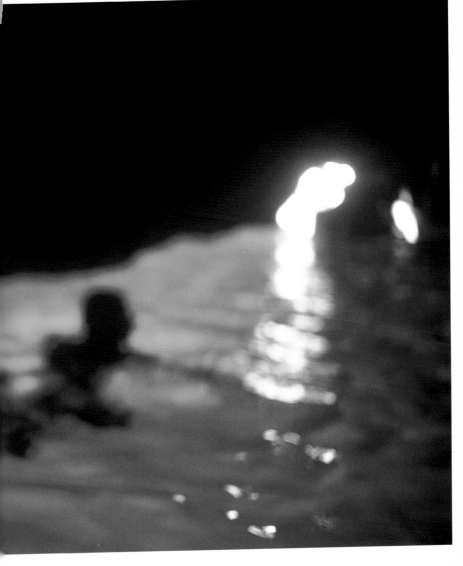

**(previous page) Gigi in the blue grotto with light, Capri, Italy, 1997.** Naples an[d] the islands of its archipelago have provided the setting for many of Goldin['s] photographs since the late 1980s. This image, which is also included in he[r] 'Italian' volume, clearly shows her gradual move away from a realistic formula[-] tion to one that is more painterly and imaginative. Goldin's friend Gigi is shot [in] the iridescent light of the blue grotto in Capri, during the time the artist spe[nt] on the island working on *Ten Years After*.

**The sky on the twilight of Philippine's suicide, Winterthur, Switzerland, 199**[ ] News of the suicide of Philippine, a young teenage friend, reached Goldin unex[-] pectedly on the day of the opening of her *I'll Be Your Mirror* retrospective a[t] the Winterthur Museum, Switzerland. That afternoon, under the effect of som[e] curious natural phenomenon, the stormy sky turned blood-red. This photo[-] graph, intended as a tribute to her dead friend, is a perfect example of the wa[y] in which landscape photography can sometimes assume an inward and subt[le] narrative significance, and a strong element of emotion and recollection.

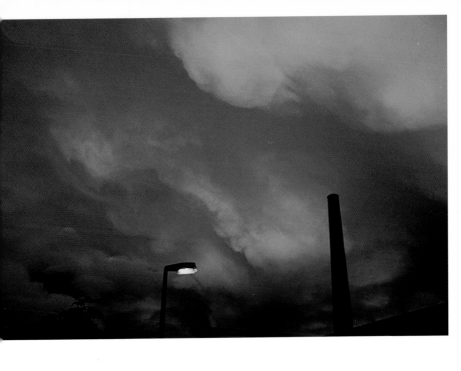

**Ulrika, Stockholm, Sweden, 1998.** Balanced on the cusp between religious iconography and the magic of portraiture, this photo of Ulrika, the daughter of the gallery-owner who exhibits Goldin's work in Sweden, is among the most beautiful of her images of childhood. This interest has developed gradually and appears in many other pictures going back to the early 1980s. Since then, in addition to a 1996 exhibition at Matthew Marks Gallery in New York exclusively devoted to children, there has been the most recent of the 'grids' *Maternity grid*, made up of twenty-four images exploring every facet of the relationship between a mother and her newborn baby.

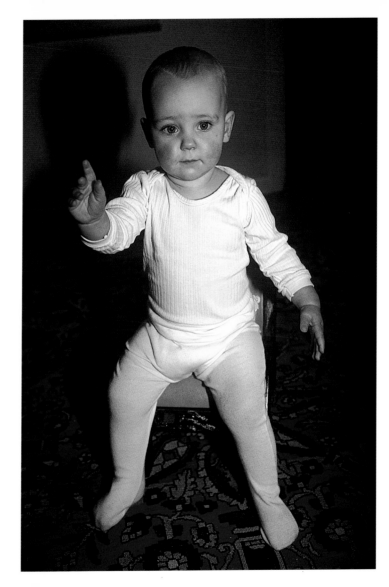

**Self-portrait on bridge, golden river, Silver Hill Hospital, Connecticut, USA**
**1998.** This recent image combines Goldin's hallmark self-portraiture with her rediscovery of nature as a setting in which to depict the solitude of the individual. It is significant that the photograph dates from what was a very difficult time for her, and it springs from a state of mind in total contrast to the mellow golden quality of the landscape. It is a photo redolent of tragedy and secret but also suggests the promise of hope and reconciliation.

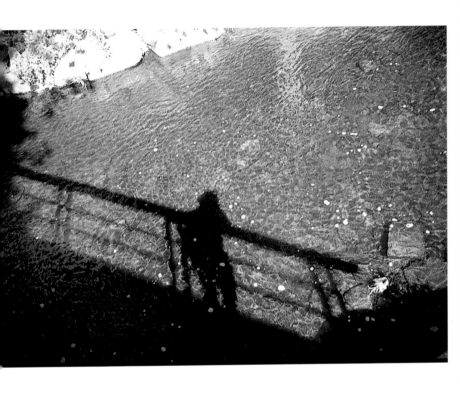

**Self-portrait on the rocks, Levanzo, Sicily, 1999.** This self-portrait is one
many that catch Goldin at a private moment, a station in her life-long journey
a person and as an artist. Many of these shots, used in the 1994 slide show *
by Myself*, have over time become important markers in her artistic develo
ment, genuine thematic and conceptual turning-points similar to *Nan one mon
after being battered*, 1984 (page 47).

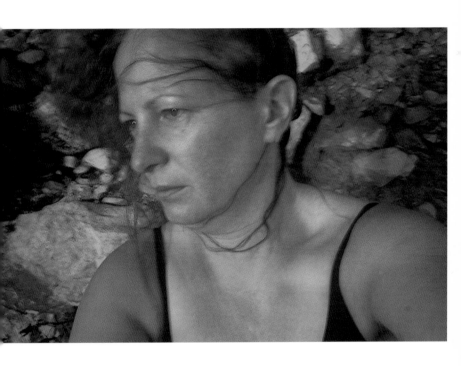

**Guido with his mother and grandmother, Turin, Italy, 1999.** This photogra[p]
was taken in Guido's mother's house in Turin and reflects Goldin's interest
family life and intimate relationships. It is a powerful image, with a complex pl
of colour, shadow and gaze, and is significant because of the way in which t[
weight of passing time is dramatically foregrounded.

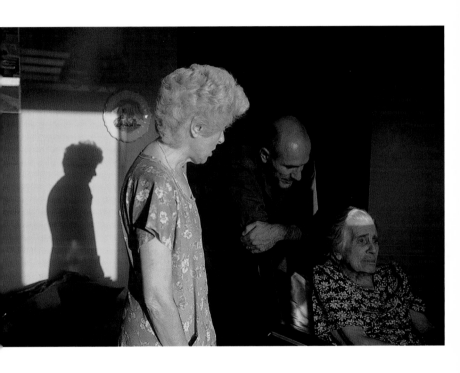

Joana with Valerie, and Reine in the mirror, L'Hôtel, Paris, France, 1999. T
cycle from which this photograph (originally intended for the French newspap
*Libération*) is taken, marks the beginning of what might be thought of as Goldi
Paris period. It is included in a very recent 'grid' that places a strong empha
on sensuality and seduction, and is a distillation of Goldin's familiar mot
in depicting the feminine world, from the idea of the reflection in the mirror
intimacy between women. The red tones (with their sophisticated flavour of t
boudoir) that dominate the cycle heighten the aura of feminine mystery that is
some extent the subtext of all these images.

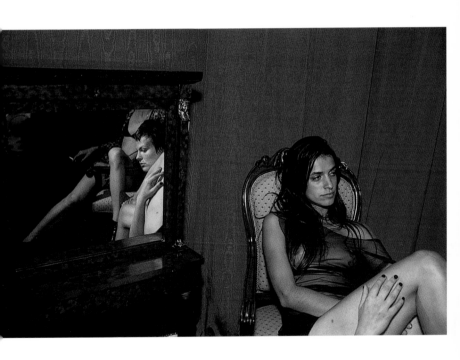

**Joana laughing, L'Hôtel, Paris, France, 1999.** Joana, a young Parisian ope[r]
singer, has been one of Goldin's favourite subjects in recent times. She h[as]
always been interested in the grammar of female beauty and found in Joana [a]
perfect example of seductive power that comes in this case more from t[he]
irregularity of her features and the magnetism of her persona and expressi[on]
than from classical conventions of beauty.

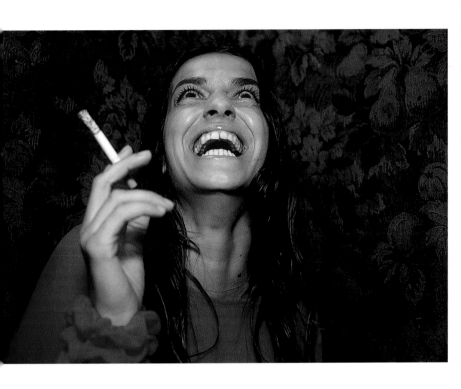

**Clemens and Jens, hand in mouth, L'Hôtel, Paris, France, 1999.** Despi
Goldin's close experience of homosexuality, few of her photographs emphasi:
so explicitly its erotic element as does this one. It belongs to the Paris seri·
(intended for *Libération*) and shows two young lovers at an intimate momer·
Clemens, a stage actor from Berlin and an old friend of Goldin's, appears·
many of her photographs as a prototype of a dreamy male beauty.

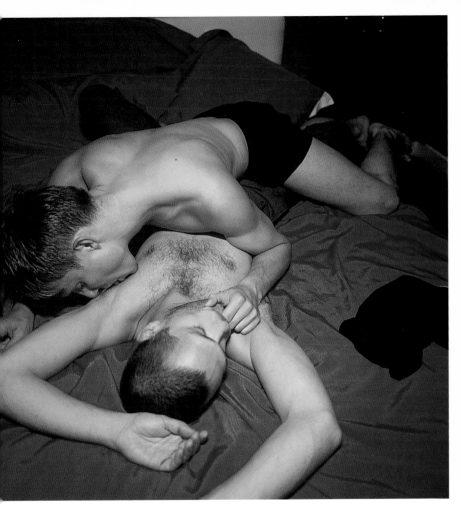

**Joana and Aurèle making out in my apartment, New York City, USA, 199**

Sexuality has always been a dominant theme in Goldin's work. But in this rece
photograph of Aurèle and Joana, taken at Nan's house in New York, there is
different kind of formal composition, not seen in other images of the same kin
such as those from *The Ballad*. All signs of roughness have disappeared (a
though they are still present in other photographs on the same theme), to b
replaced by a more romantic and tender approach.

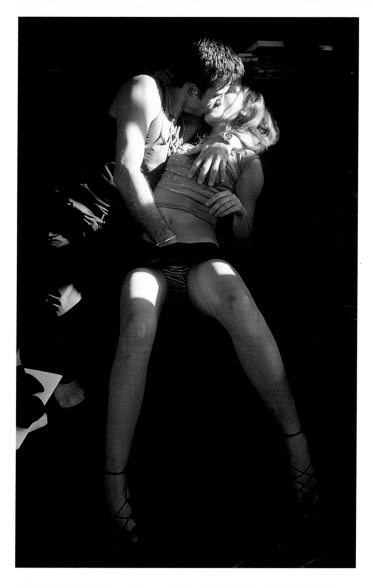

**French family before the bath, Sag Harbor, USA, 2000.** Aurèle and Joan

photographed here with Joana's child Lou, appear in a long series of images

family life taken while they were staying at Goldin's house in Sag Harbor.

young family's domestic rituals are recorded by someone who is involved in the

lives, against the background of an experiment in communal living. This cyc

contains some of the most intimate images in Goldin's recent work. It is the fru

of an association that is primarily private, but which is then transformed,

always happens in Goldin's photography, into a sophisticated work of art.

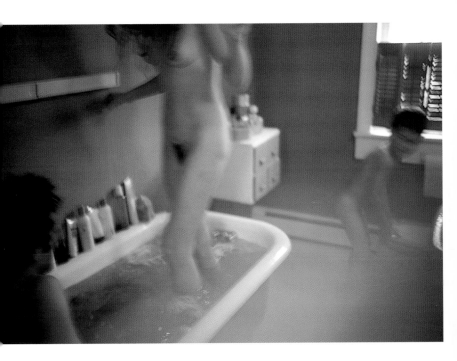

**Joana's back in the doorway at the Châteauneuf-de-Gadagne, Avignon, France 2000.** Joana's nudity, displayed with great naturalness as if it were a form dress, immediately captivated Goldin, who has made it the subject of hundre of photographs in the past year. Joana's casualness in relation to her own bo rids the image of any erotic overtones, and it becomes a nude in the classic Greek sense of the word. However, the traditional organization of the pictu is combined with a particular way of handling the background, adding mov ment and placing emphasis on the narrative aspect, which is its real centre interest — the woman and her lover gazing at each other from a distance.

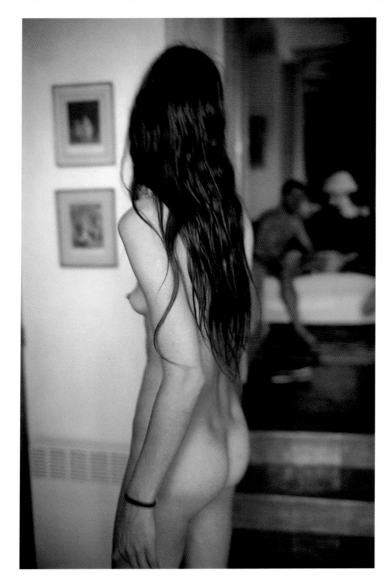

| | |
|---|---|
| **1953** | Born 12 September, Washington DC. |
| **1969–1972** | Begins to photograph, aged 16. Attends Satya Community Scho[ ] Lincoln, Massachusetts, which she calls the 'hippie free high schoc[ ] |
| **1972** | Has first exhibition of early black-and-white photographs [ ] drag queens. |
| **1977** | Graduates from the School of the Museum of Fine Arts, Boston, w[ ] a Batchelor of Fine Arts degree. |
| **1978** | Moves to New York City. Shortly afterwards, she begins to create *T[ ] Ballad of Sexual Dependency*. From this time, her life and commun[ ] in New York and various European cities become the focus of h[ ] work for the next fifteen years. |
| **1985** | Her work is included in the Biennial Exibition at the Whitney Museu[ ] New York. |
| **1986** | *The Ballad of Sexual Dependency* is published and the work is exhi[ ] ited at the Burden Gallery, New York. |
| **1987** | *The Ballad of Sexual Dependency* wins the Photographic Book Pr[ ] of the Year, Rencontres internationales de la photographie d'Arle[ ] |
| **1989** | Curates the exhibition 'Witnesses: Against Our Vanishing', New Yo[ ] about the effects of AIDS on her community. Awarded the Came[ ] Austria prize for contemporary photography. |
| **1990** | Awarded National Endowment for the Arts grant and the Moth[ ] Jones Documentary Photography Award. |
| **1991** | Spends a year in Berlin as part of the DAAD Artists-in-Resider[ ] programme. Publishes *Cookie Mueller*, photographs document[ ] their close friendship up to Cookie's death from AIDS in 1989. |
| **1992** | Publishes *The Other Side*, comprising photographs of transvesti[ ] and transsexuals taken over a twenty-year period. |

**1993** 'The Ballad' exhibition travels around Europe. Publishes *Vakat*, a series of photographs of hotel rooms, with Joachim Sartorius.

**1994** Wins the Brandeis Award in Photography. Publishes *Tokyo Love*, a collection of photographs of Tokyo's youth, made in collaboration with Japanese photographer Nobuyoshi Araki. Also publishes *Double Life*, photographs by herself and David Armstrong of their community of friends during their 25-year friendship, and *Desire by Numbers*.

**1995** Makes the film *I'll Be Your Mirror* for the BBC.

**1996** Mid-career retrospective at the Whitney Museum of American Art, New York held in October. This exhibition then travels around major European museums. A catalogue, *I'll Be Your Mirror*, is published to accompany the show. Film of *I'll Be Your Mirror* wins The Teddy Gay and Lesbian Film Award for Best Essay Film at the International Film Festival, Berlin.

**1998** Publishes *Ten Years After: Naples 1986–96*.

**1999** Publishes *Couples and Loneliness*. Creates installation *Thanksgiving* at the White Cube gallery, London.

**2001** Major exhibition of her latest work scheduled for October at the Centre Georges Pompidou, Paris, which will then travel to various European venues.

Photography is the visual medium of the modern world. As a means of recording, and as an art form in its own right, it pervades our lives and shapes our perceptions.

**55** is a new series of beautifully produced, pocket-sized books that acknowledge and celebrate all styles and all aspects of photography.

Just as Penguin books found a new market for fiction in the 1930s, so, at the start of a new century, Phaidon **55**s, accessible to everyone, will reach a new, visually aware contemporary audience. Each volume of 128 pages focuses on the life's work of an individual master and contains an informative introduction and 55 key works accompanied by extended captions.

As part of an ongoing program, each **55** offers a story of modern life.

**Nan Goldin** (b.1953) is most famous for her long-term photographic record of her immediate circle, *The Ballad of Sexual Dependency*. Her work often breaks social taboos with its explicit exploration of relationships, sexuality and eroticism. More recently, her images have shown the devastating effect AIDS has had on this community of friends.

**Guido Costa** curates exhibitions worldwide and his writing on art and photography has been widely published. He has worked closely with Goldin for many years and collaborated with her on the book *Ten Years After* (1996).

Phaidon Press Limited
Regent's Wharf
All Saints Street
London N1 9PA

Phaidon Press Inc.
180 Varick Street
New York NY 10014

www.phaidon.com

First published 2001
©2001 Phaidon Press Limited
Translation from Italian:
Imogen Forster

ISBN 0 7148 4073 4

Designed by Julia Hasting
Printed in Hong Kong